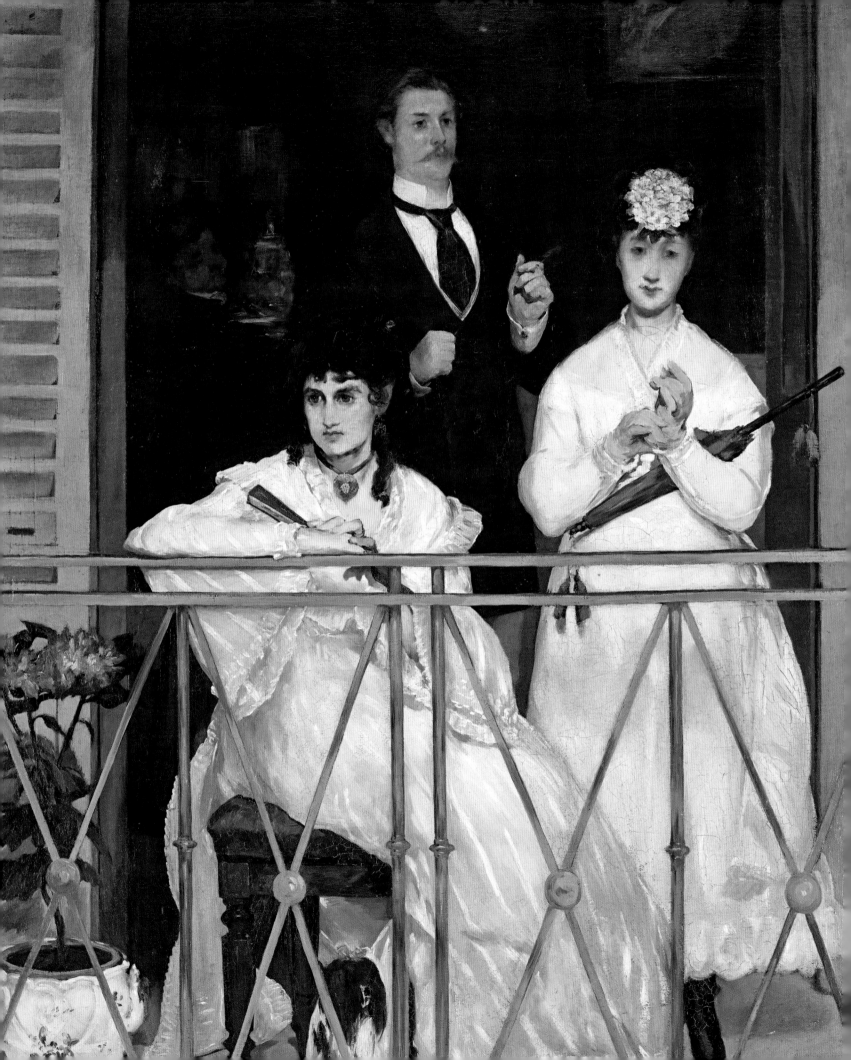

Impressionism
13 Artists
Children Should Know

Florian Heine

PRESTEL

Munich · London · New York

Contents

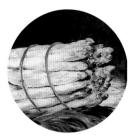

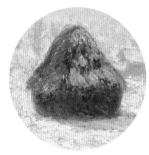
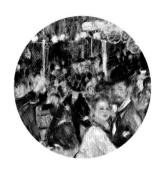
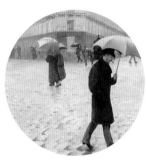

"Impressionist" is the name we give to a special kind of painter. The Impressionists first began painting in France during the late 19th century. They had new ideas about the way we should paint. Nowadays, their pieces are world famous and priceless. Yet in the 19th century, virtually nobody wanted to own them, and art critics made fun of them. We look at Impressionist pictures very differently today. These paintings often amaze us, and they show how much the Impressionists changed the way we see art.

In the 19th century, the Académie des Beaux-Arts (or Academy of Fine Arts) in Paris controlled what and how art should be made. Paintings at that time had to have a central theme: ancient gods, figures from the Bible, or something on the subject of history. The pictures had to be painted precisely, and hardly a brushstroke was allowed to be seen. The Impressionists, on the other hand, were aiming to do something completely different when they staged their first exhibition in 1874 …

In this book, you will get to know 13 Impressionist painters who went on to revolutionize the world of art with their creations.

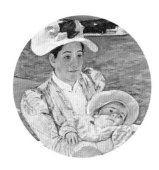

Born
January 23, 1832
in Paris
Died
April 30, 1883
in Paris

Manet was a bad
pupil at school. That's
why he wanted to
become a naval
officer at the age of
16 and then travel
by ship for half a year
to South America.

Édouard Manet

During Manet's lifetime, his hometown of Paris changed a great deal. Many of the old buildings and streets were replaced by new, broad boulevards and attractive houses.

People enjoyed their free time in the new cafés and bars. Manet sought to capture this modern lifestyle. He was of the opinion: "You have to live and paint life as you see it." And that's why he painted his friends, for example, in a big open air café, where a huge number of people were spending a fine afternoon. Surprisingly, this picture got some people extremely upset. They believed such scenes should never be depicted in art. For Manet, however, they should.

What Manet aimed to avoid was to paint things in an orderly fashion, where barely a brush stroke could be seen. In those days, artists used to paint in a studio with very even light. The pictures they produced often showed all the figures in a clearly defined and well-lit way. Outside in the cafés, however, the light was totally different. It was bright in some places and dark in other places, and not every person could be easily recognized. This explains why Manet did not paint each person in exactly the same manner. Some of his figures appear hazy; and if you look at them from quite close up, you will see that they were

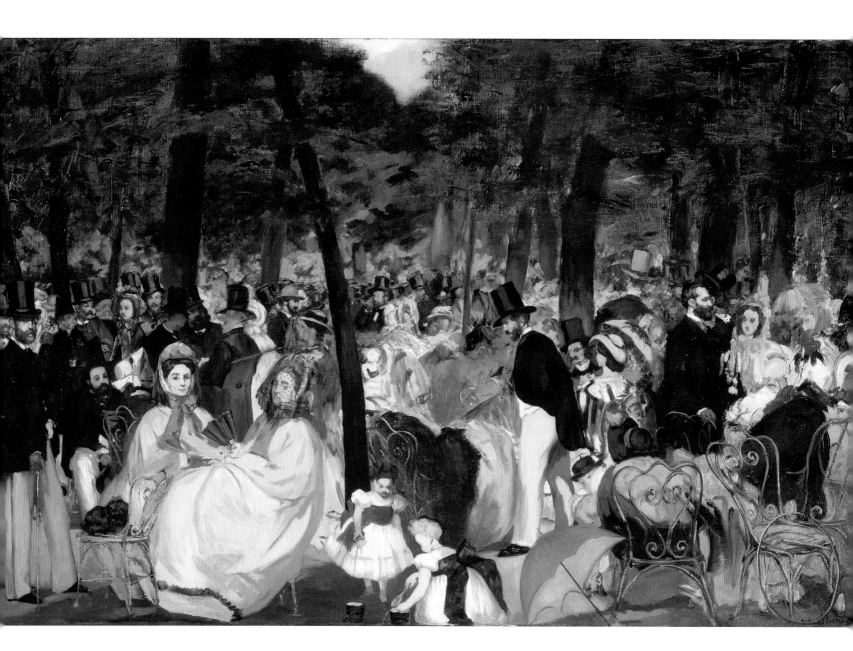

Édouard Manet,
Music in the Tuileries Gardens,
1862, National Gallery, London

Many of Manet's friends can
be seen in this painting, such as
Jacques Offenbach, the famous
composer. Manet, too, can be
seen in the far left corner.

painted with only daubs of color. When you are in a café yourself, you too
won't be able to spot every person there. And that is how Manet wanted
to paint – showing simply what his eyes perceived.

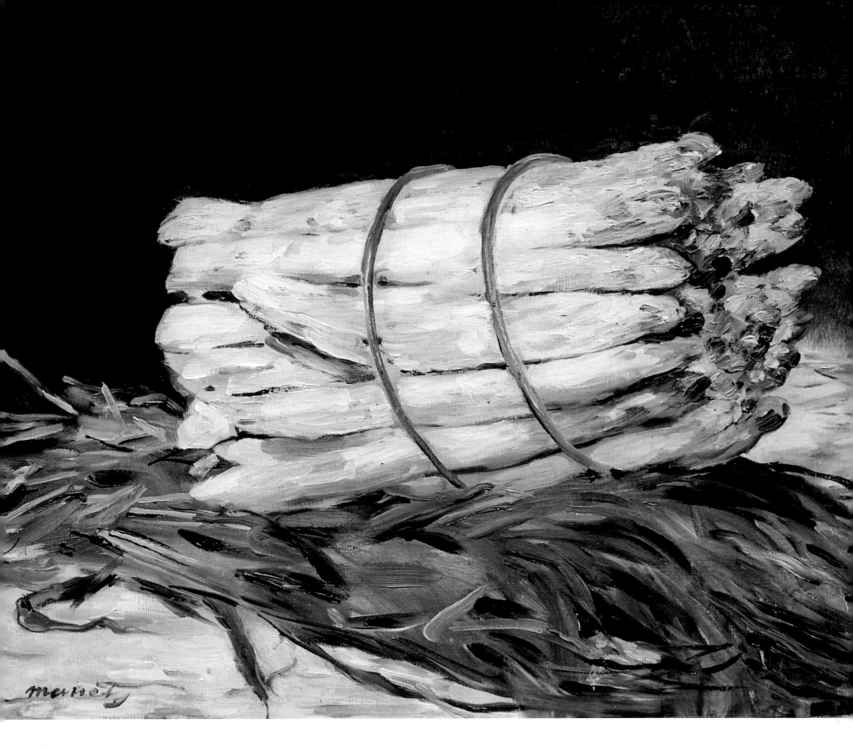

Édouard Manet, *Bunch of Asparagus*, 1880, Wallraf-Richartz-Museum, Cologne

In 1880, Manet painted a still-life of a bunch of asparagus stems. Even this picture was not "orderly" and exact. And though you recognize the artist's thick brush strokes, the asparagus stems still look good enough to eat.

Quiz Question
Why did Manet paint a single asparagus?
(Solution on page 46)

6

Manet was not permitted to show his art at many important exhibitions because so many people got upset at his style. This criticism definitely annoyed him. But he still stood by his modern way of painting.

Manet was friends with most of the Impressionists, but he never exhibited with them. They admired him because he went against the rules and painted just as he found things. Manet's daring attitude about art encouraged the younger painters to try out their own ideas.

Édouard Manet,
Asparagus, 1880,
Musée d'Orsay, Paris

Still-lifes often seem a bit boring, but this single asparagus stem is really quite charming.

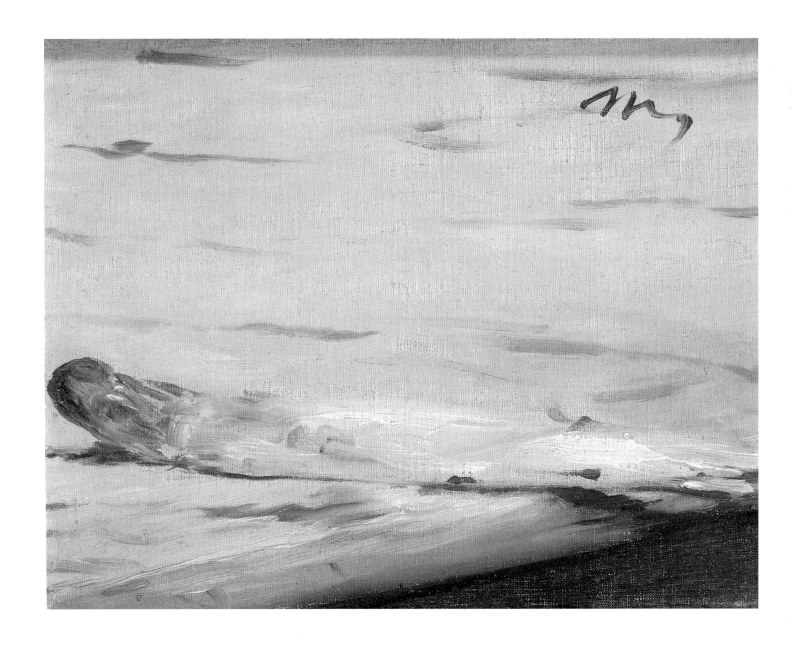

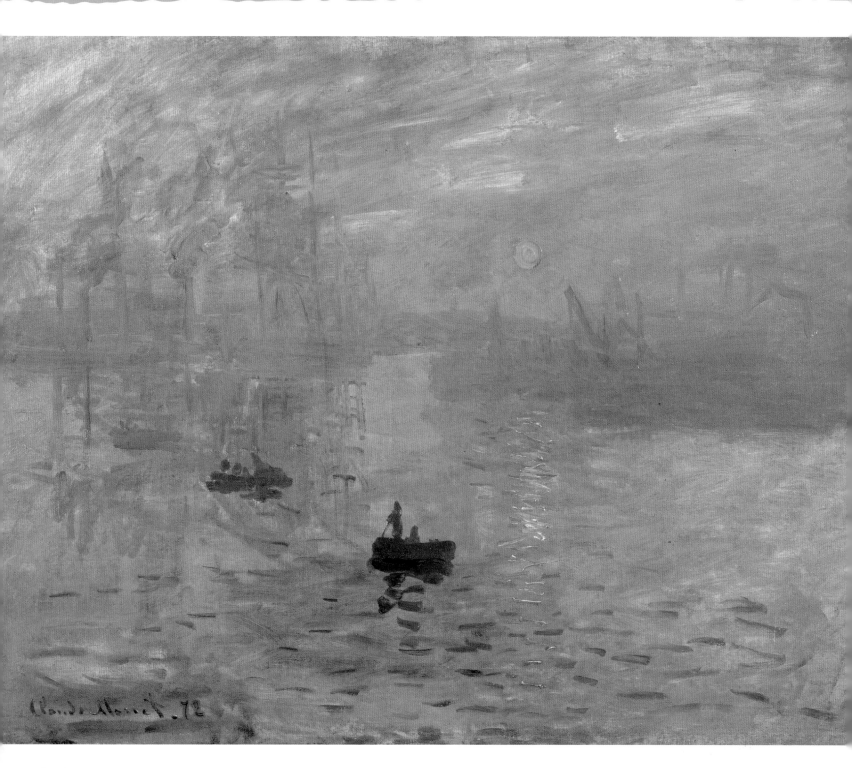

Claude Monet, *Impression Sunrise,*
1872, Musée Marmottan, Paris

Armed robbers stole this and 8 other
paintings from the museum in 1985. It was
not recovered until 5 years later.

1872 British artist Eadweard Muybridge is the first to photograph a galloping horse.

865 1870 1875 1880 1885 1890 1895 1900 1905 1910 1915 1920

Claude Monet

Claude Monet preferred to paint landscapes, and he often did so when out of doors. Painting outside makes complete sense to us today. But back then, artists painted landscapes in the studio, basing their pictures on a drawing or on their own imagination.

Born
November 14, 1840
in Paris
Died
December 6, 1926
in Giverny

Monet fell in love with his model, Camille Doncieux. She also became his wife and they had two sons together. Camille died in 1879 at just 32 years of age. Monet lived until he was 86.

Monet recognized that colors in nature were different from those seen in paintings by the Old Masters. These pictures often showed nature in an even light and with grey or black shadows. But in nature, colors of objects vary depending on their settings and on the way light falls upon them. And shadows are not simply grey or black, but can be colorful. For example, on a sunny day and in a snow-covered landscape, shadows have a bluish hue because of the blue sky. This is what Monet and his friends recognized.

Monet wished to paint outdoors no matter what. Given that outside light could change at any moment, he needed to adopt a completely different method of painting. Monet's solution was to apply paint on the canvas with quick, short strokes of his brush. Details did not interest him as much as the overall effect, and the impression one got from seeing the picture.

For these reasons, he called his best known painting *Impression, Sunrise*. It shows a harbor scene in the morning mist. Monet focused not on the dock workers or the ships, but on the atmosphere of the sunrise through the fog. When he exhibited the painting at a show in 1874, there was a great commotion. People argued that Claude simply could not paint well, and that this picture was not really a painting at all. For Monet, though, it was.

Quiz Question
How long do you think it took Monet to paint *Impression, Sunrise*?
(Solution on page 46)

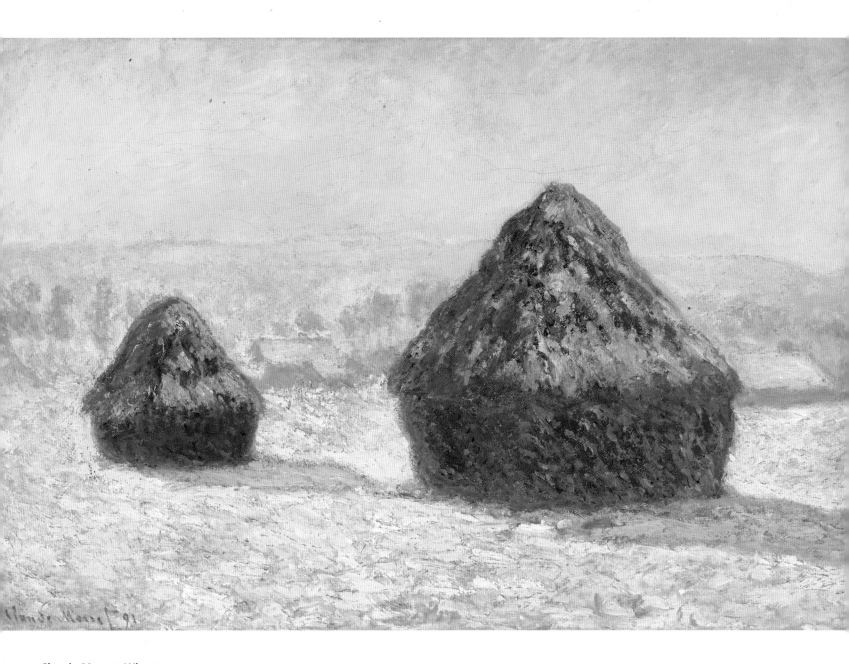

Claude Monet, *Wheat Stacks, Snow Effect, Morning*, 1891,
The J. Paul Getty Museum, Los Angeles

Monet constantly tried to capture the changing light in his paintings. He often painted whole sequences of pictures of the same view, like in his famous Haystacks series.

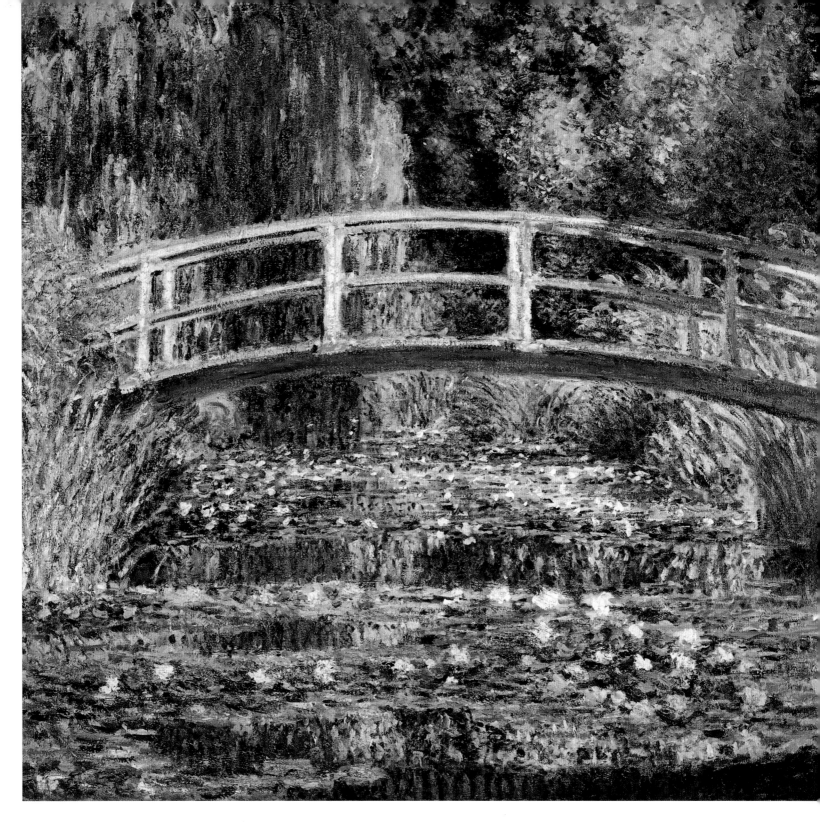

Claude Monet, *Water Lilies and Japanese Bridge,*
1899, Princeton University Art Museum

At some point, Monet did actually make enough money
from his paintings to enable him to buy a house with a
big garden in Giverny near Paris. Six gardeners worked
for him and he painted almost only views and flowers of
his splendid and enchanting garden.

Further reading
You can see how Monet
lived at his home in Giverny,
France at: www.fondation-
monet.com.

approx. 1826 French inventor
Joseph Nicéphore Niépce
produces the first known
photograph

1851 English painter William
Turner dies in London

1805 1810 1815 1820 1825 1830 1835 1840 1845 1850 1855 186

Born
February 25, 1841
in Limoges
Died
December 3, 1919
in Cagnes-sur-Mer

Renoir began
painting at a young
age. He had already
started an appren-
ticeship as a porcelain
painter at the age
of 13.

Auguste Renoir

"One day, we ran out of black paint – and that is how Impressionism was discovered." This is how Renoir explained the birth of the new artistic movement.

The Impressionist technique was not that simple at all. But there is an element of truth in what Renoir said because the special feature of Impressionism is the use of bright and vivid colors. The Impressionists wanted to create paintings as bright and colorful as life itself.

Renoir painted exactly such a picture in 1876 with his *Dance at the Moulin de la Galette*. It shows a merry group of Renoir's friends having fun in a café on a summer afternoon. The scene is set in shimmering light and seems so lifelike that you can almost hear the music and laughter.

The café was conveniently located near Renoir's studio, which made it easy for him to bring his canvas there. Renoir also took advantage of another important invention: the paint tube. Paint tubes were small and light-weight, and the paint in them didn't dry up as quickly as traditional paint. Therefore, they were perfectly suited for painting outdoors. Renoir com-mented: "Paint tubes enabled us to paint in the open air. Without them there would have been no Impressionism".

As Renoir got older, he developed a disease called arthritis that crippled his hands. In order to paint, a brush had to be tied to his hand because he could no longer hold on to it. Why don't you try this painting method yourself? It's not so easy! Renoir though was able to do it, and he created many great masterpieces at the end of his life.

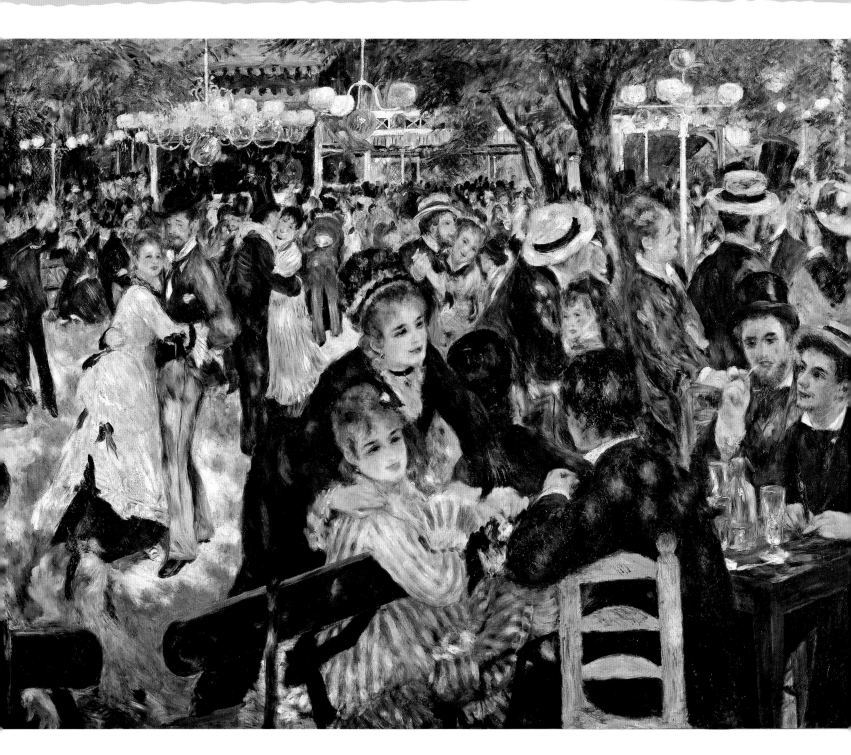

Auguste Renoir, *Dance at the Moulin de la Galette*, 1876, Musée d'Orsay, Paris

As with earlier paintings by Manet, this large picture was unusual because it depicted people's leisure time. One critic wrote: "This is an historical picture. Nobody would ever before have come across the idea of reproducing an outdoor scene on such a big canvas."

1829 The first boat race between
Oxford and Cambridge universities

1861 Abraham Lincoln
becomes President of the
United States

1805 1810 1815 1820 1825 1830 1835 1840 1845 1850 1855 1860

Gustave Caillebotte

It took a long time before the young painters of the Impressionist period could make a living from their new art. Fortunately, however, one of their friends was Gustave Caillebotte.

Born
 August 19, 1848
 in Paris
Died
 February 21, 1894
 in Paris

Gustave Caillebotte had a very significant stamp collection that can still be seen at the British Museum in London.

Tip
Caillebotte bought many of his friends' paintings. After his death, his collection became the heart of the major Impressionist collection at the Musée d'Orsay in Paris. You can see the paintings there if you visit Paris. Or you can look them up on: www.musee-orsay.fr

Gustave's parents had left him and his brother quite a lot of money. Caillebotte used this wealth to help his friends, buying many of their paintings. Gustave was an outstanding painter in his own right, but he painted much differently from other Impressionists. His pictures are not created as spontaneously and loosely, but instead are much more exact and orderly. Because Gustave's art looked more traditional, many critics championed him as just about the only Impressionist who could paint "correctly."

At first glance, his works do not seem to be Impressionist. Yet in their own way, they are indeed. One of the most significant innovations of Impressionism was portraying everyday life in Paris. Caillebotte's *Paris Street, Rainy Day* is a typical example – what can be more normal than people walking along the street?

The picture is, however, almost 10 feet (3 meters) wide and over 6 and a half feet (2 meters) deep. This size makes the people in the painting look especially lifelike. If you stand in front of the picture, you almost feel the need to step to one side and let the couple on the sidewalk pass you! Caillebotte wanted to show through its size and its complex style that such a modern painting could be just as impressive as the traditional large paintings in museums.

1872 Thomas Adams
invents chewing gum

1893 The first Ferris Wheel appears
at the World's Fair in Chicago

865 1870 1875 1880 1885 1890 1895 1900 1905 1910 1915 1920

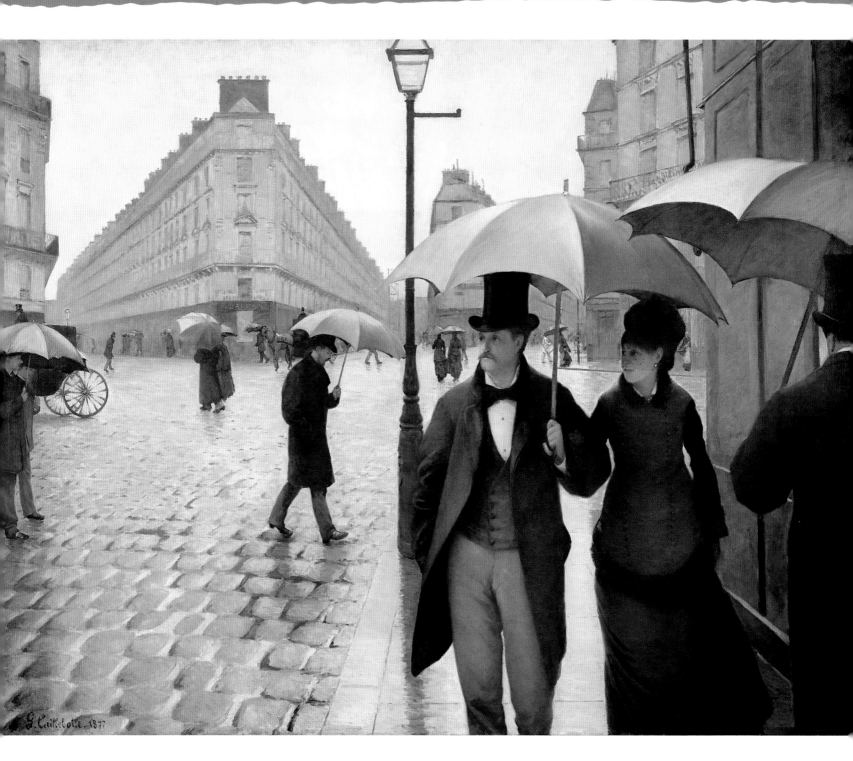

Gustave Caillebotte, *Paris Street, Rainy Day*,
1877, Art Institute Chicago

Large, modern boulevards were built at the time
of the Impressionists. They still look almost the
same to this day, except for the trees and cars.

Edgar Degas, *Ballet Dancers / The Star (L'étoile)*, 1876/77, Musée d'Orsay, Paris

Degas often painted from unusual angles. This painting was done from a stall very close to the stage.

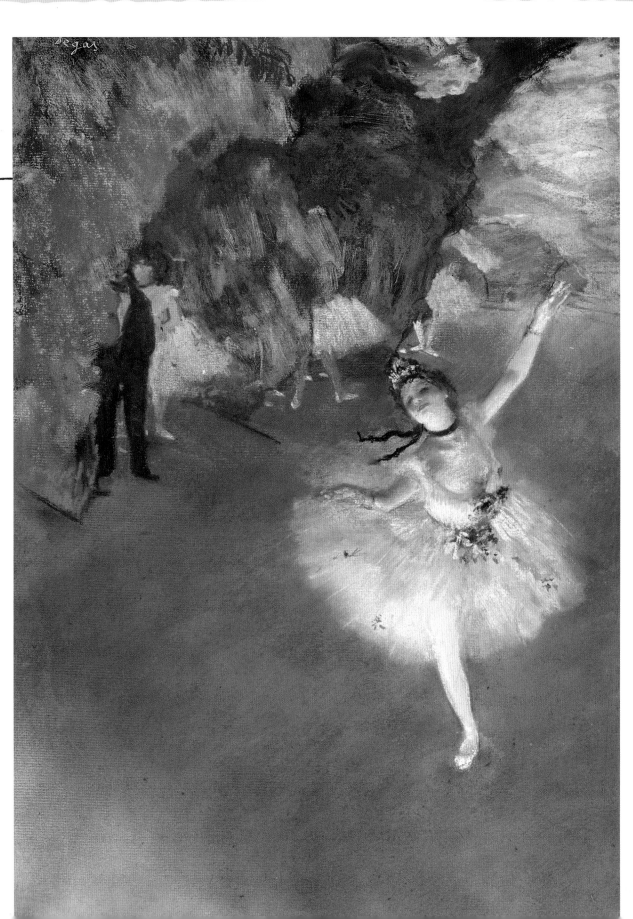

1870s Blue jeans
first go on sale

1894 Charles Francis Jenkins shows
first motion picture in Richmond, Indiana

1865 1870 1875 1880 1885 1890 1895 1900 1905 1910 1915 1920

Edgar Degas

Degas was interested in anything that moved: horses on a race track, people in the street, and – above all – dancers at the ballet.

When artists want to paint figures in their work, they often use models who have to remain in the required pose until they have been correctly sketched. This is what you learn at art school. And if you become really good at it, you can draw people very quickly … even when they are in motion.

Degas was able to capture movement better than almost any other artist. He often went to the theater and drew the dancers as they rehearsed. They did not stand still and wait for him. He had to draw them quickly in order to capture the correct impression and the right moment.

Degas especially favored the use of pastel shades. This soft chalk paint was much more practical for use in the theatre than oil paint. Edgar could not only work much more speedily with it, he could also mix the paints very easily by using his fingers.

Born
July 19, 1834 in Paris
Died
September 27,
1917 in Paris

Edgar Degas was the son of a banker and had four siblings. His mother died when he was just 13 years old.

Quiz Question
How much money do you think Degas received when he sold the painting on this page?
(Solution on page 46)

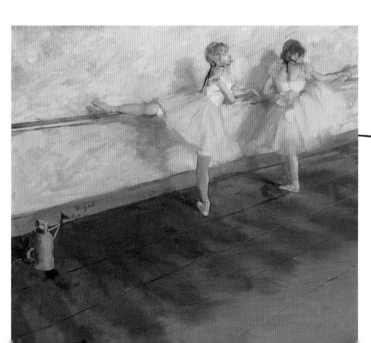

Edgar Degas,
*Dancers Practicing
at the Bar*, 1877,
Metropolitan Museum,
New York

Watering cans were often used to keep the floor damp so that dust would not come up during the dance.

Edgar Degas, *At the Races*, 1877/1878, Musée d'Orsay, Paris

Everything in this picture looks random: the movement of the horses and the people, the whole frame looks as if it was photographed.

Photography also helped Degas better portray movement. During the artist's lifetime, new kinds of cameras enabled people to take photos very quickly. Degas used such cameras to photograph men and women, and he often reproduced the images in his own paintings.

Degas became blind in 1889 and began to work as a sculptor. He used clay and solid wax to model delicate figures, especially horses and his beloved female dancers. It is astonishing to imagine how Edgar managed to do this. Why don't you try it yourself? Just have a go at shaping a figure from Play-Doh – it's not so easy!

Try to draw your friends while they are playing sports or dancing. It requires a lot of practice, but it's great fun, too. You can even take photos of your friends and then make drawings of the pictures you've taken. Let's find out how good you are at showing movement!

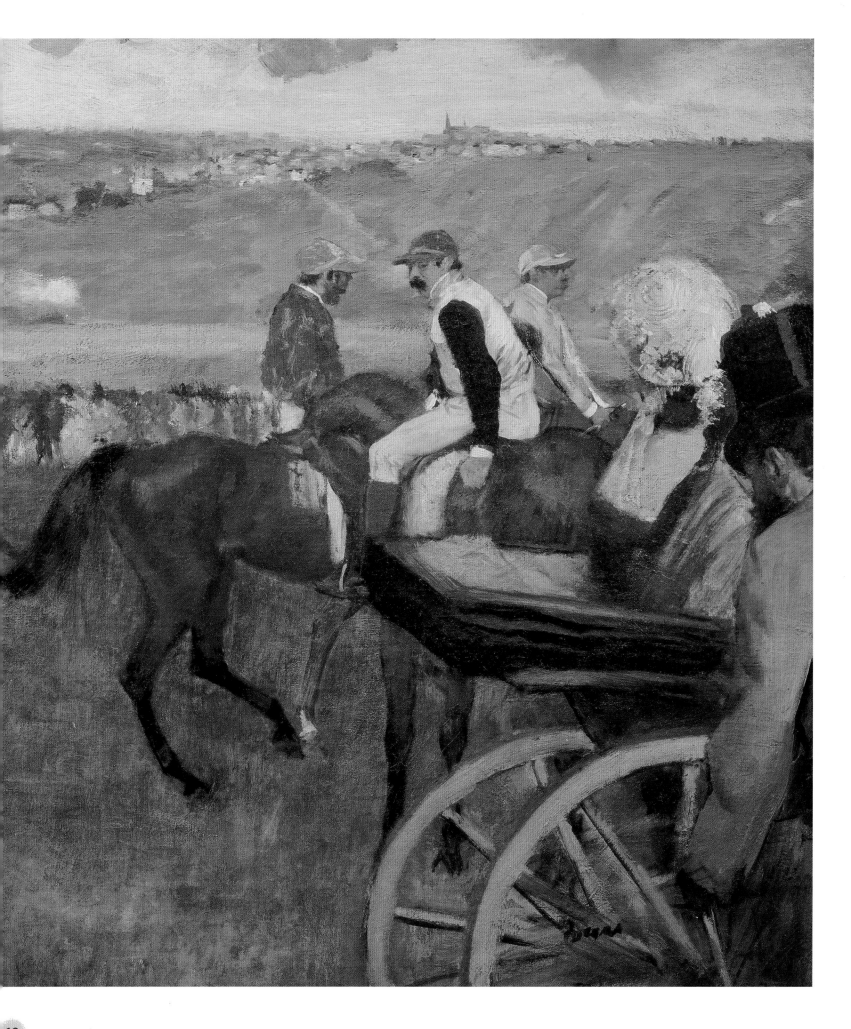

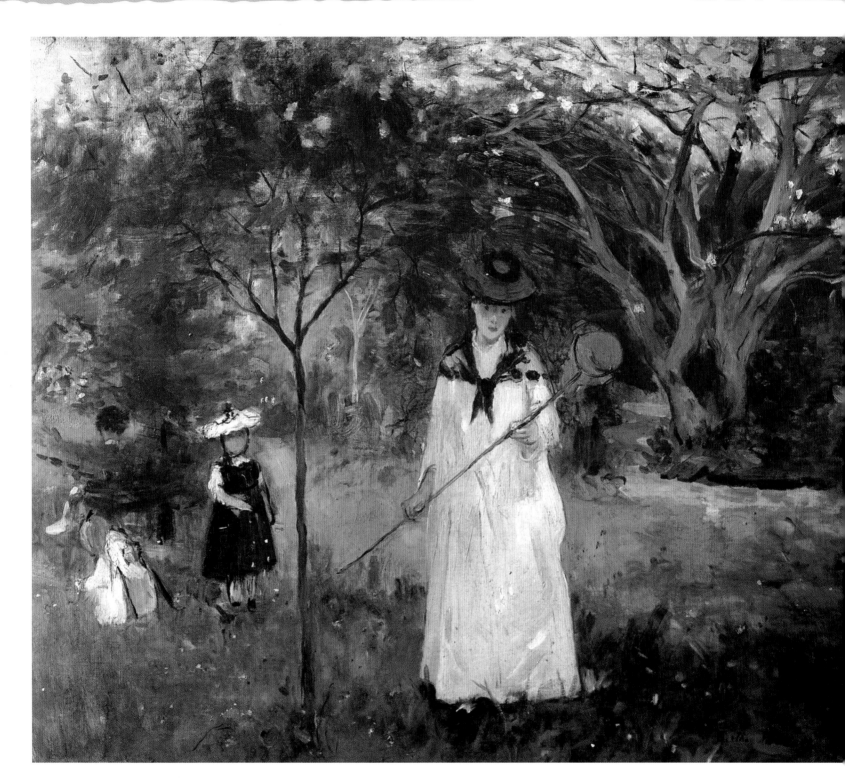

Berthe Morisot, *Butterfly Hunt*, 1874, Musée d'Orsay, Paris

In those days people wore elaborate dresses and hats even when they
were chasing butterflies. A few nice brushstrokes were all Berthe needed
to show the little girls and the blossoms.

Berthe Morisot

"Five or six crazy people, one of them a woman, exhibited their paintings," is what a newspaper reported in 1874 about the Impressionists' first exhibition in Paris. One of these "mad" people was Berthe Morisot.

Born
January 14, 1841
in Bourges
Died
March 2, 1895
in Paris

Berthe Morisot was married to the brother of Édouard Manet. They had two daughters together.

In the Paris of those days, many daughters of well-to-do families learned to play musical instruments and to draw and paint a little. These women often used their artistic skills to create family portraits. Nowadays, we would simply use a camera.

Berthe Morisot and her sister Edma had private painting lessons because, in the 19th century, young ladies were not permitted to attend the Art Academy. Their tutor was a very famous painter named Camille Corot. He immediately saw that Berthe and Edma were very talented.

Corot told their parents: "With the character your daughters have, my lessons will be geared to making them into artists and not into unimportant, capable amateurs. Do you understand what this means? In your world, it is a revolution, but I would venture to say that it is a catastrophe!"

Berthe Morisot,
Hanging the Laundry
Out to Dry,
1875, National Gallery,
Washington

Berthe preferred to paint
landscapes and families
with their children.
These subjects were
often used by amateur
women artists in Paris,
but Morisot's landscapes
and portraits were much
more modern looking.

It certainly was not a catastrophe, but it
was definitely very unusual. Both wom-
en were successful and set up their own
studio. Edma got married in 1869 and
stopped painting. But Berthe continued
… and what a sensation she became!

She got to know Édouard Manet and
became especially enthusiastic about his
art. Berthe was very pretty, and Manet
painted her again and again. His aim was
to paint her in a very modern way, and
perhaps not as respectably as how she
had learned at home. Berthe later be-
friended the Impressionists as well. She
soon became one of the "crazy people"
herself.

Worth Knowing
Right at the front of
this book, you will see
a picture that Édouard
Manet painted of
Berthe. It is called
"The Balcony."

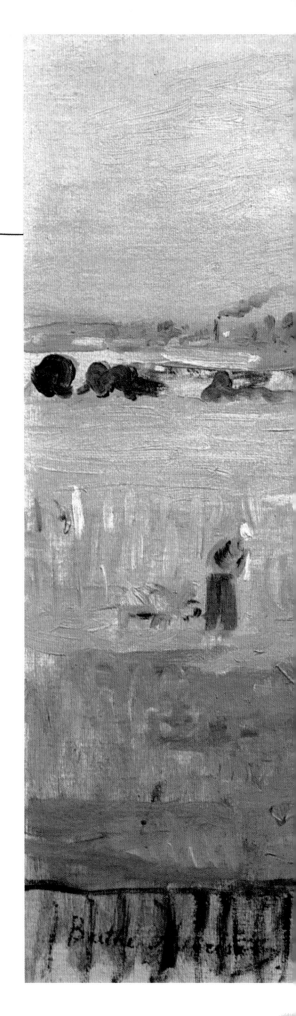

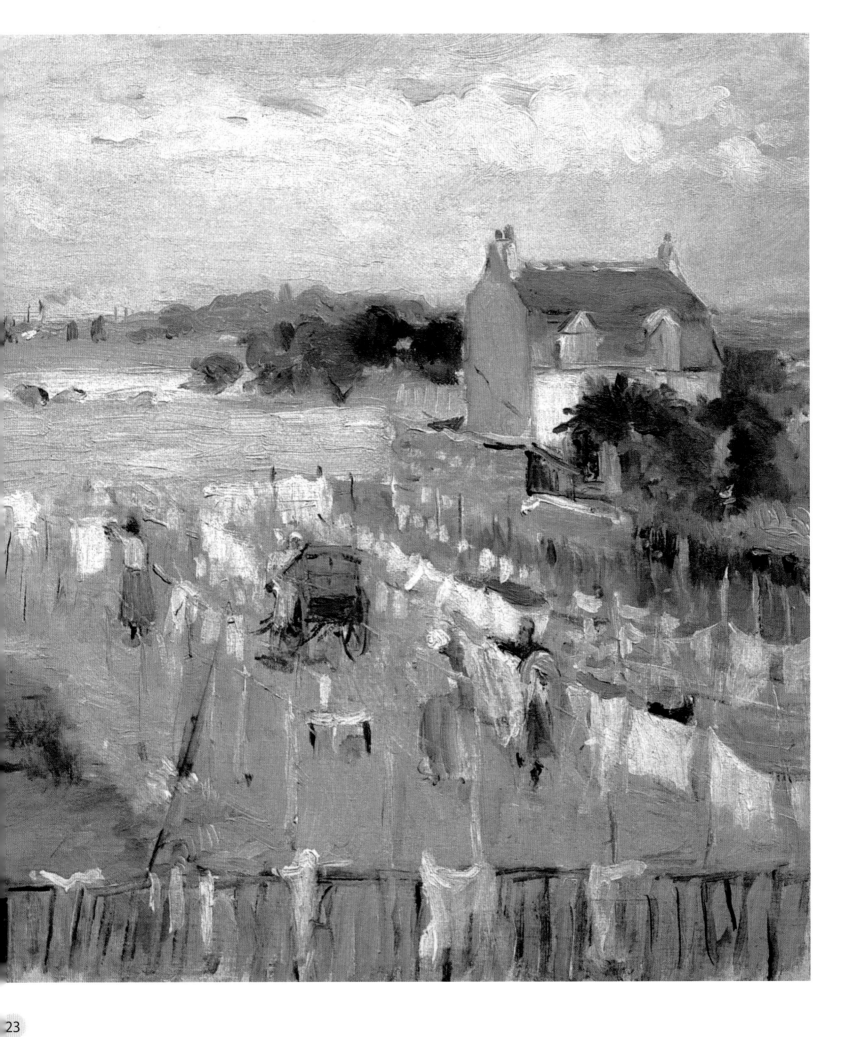

Camille Pissarro 1830–1903

1856 German scientist Johann-Carl Fuhlrott discovers Neanderthal people

1828 Spanish painter
Francisco Goya dies

1849 The Gold Rush
begins in California

| 1805 | 1810 | 1815 | 1820 | 1825 | 1830 | 1835 | 1840 | 1845 | 1850 | 1855 | 186 |

Born
July 10, 1830 in
Charlotte Amalie,
Danish West Indies,
in what is now the
American Virgin
Islands

Died
November 12, 1903
in Paris

Pissarro grew up in
the Caribbean until
he was 12 years old,
when his parents sent
him to a boarding
school in Paris. In
1855, he moved to
Paris full time and
became a painter.

Quiz Question
How much did the
population of Paris' grow
between 1850 and 1880?
(Solution on page 46)

Camille Pissarro

In Monet's paintings, hardly any people are to be seen; but in Pissarro's they are almost everywhere. He painted towns, dockyards and boulevards – basically, anything where a bubbly life took place.

Camille Pissarro was a very good friend of Claude Monet, whom he got to know at a private art school in 1859. As with almost all the Impressionist painters, Pissarro was initially unsuccessful. So to earn some money, he decorated sunshades and window blinds. But like most of the others, he stuck at his art because he was convinced the Impressionist way of doing things was the right one!

Paris was being dramatically rebuilt at that time, and many new residents moved into the city. This hustle and bustle and largely upbeat atmosphere was the favored image of Pissarro. He painted a whole series of grand Parisian boulevards. Again, it was not a case of gods or saints, but of "impressions" of a totally normal way of life!

When Pissarro and his friends exhibited their work for the first time in 1874, one critic named Louis Leroy grumbled about the paintings. He thought they looked unfinished, and he called the painters "Impressionists" in order to ridicule them. But the young artists didn't care. In fact, they soon began using the term themselves as a name for their movement. Pissarro was the oldest member of the whole

24

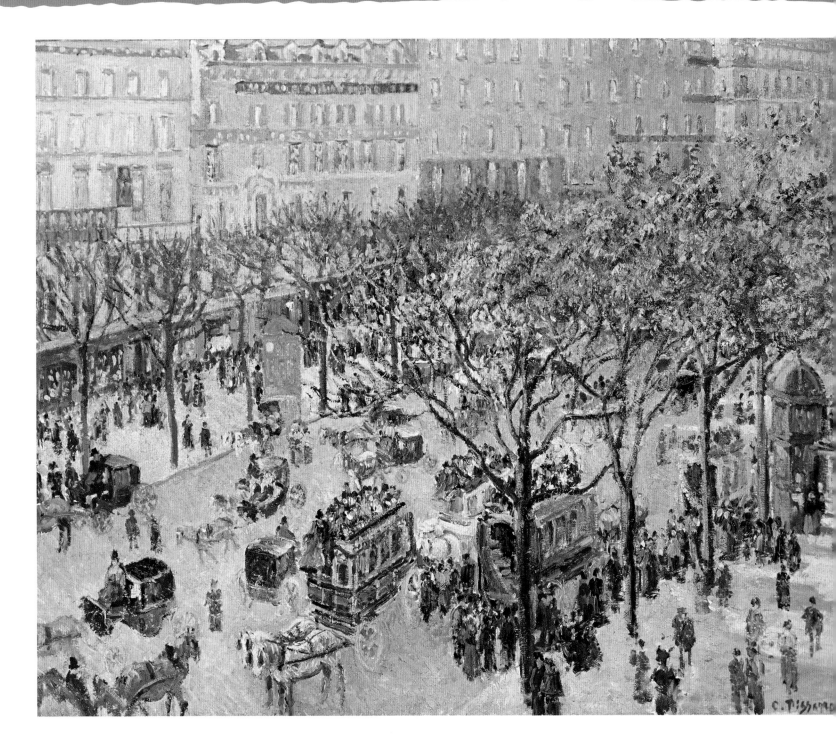

group and the only one to exhibit at all eight of the Impressionist shows.
Right to the end, he was always fascinated by new ideas.

**Have a go at this: stand somewhere in a street or on a
pathway and paint or draw everything that is going on.**

**Camille Pissarro, *Boulevard des
Italiens*, 1897, National Gallery
of Art, Washington**

From an apartment window, Pissarro
painted the hustle of the people in the
large boulevards – the horse-drawn
carriages and the many people.

Born
May 22, 1844
Allegheny City,
Pennsylvania

Died
June 14, 1926 in
Le Mesnil-Théribus
near Paris

Mary got to know the works of the Great Masters by travelling to Europe with her family. She soon wanted to become an artist herself, and she attended art college at the age of just 15.

Mary Cassatt, *The Letter,*
1891, National Gallery, Washington

In the late 19th century, many wood-block prints from Japan were appearing in France. They were completely unlike European art. The people and landscapes in these prints looked flattened, and the colors were remarkably bold and vivid. Mary and the other Impressionists liked the pictures a great deal and were inspired by them. Cassatt created many pictures in this style. You would almost think she was Japanese herself!

Mary Cassatt

Nowadays there is really nothing to stop a woman from becoming a painter. Yet at the time of the Impressionists, this was not at all conventional. For women, painting was a nice way of passing the time, but not a profession.

Mary Cassatt moved to France from America with her sister in 1874. She wanted to become an artist in Paris. She admired the work of Edgar Degas and became one of his friends. Mary was thrilled by the new ideas of the Impressionists, and she exhibited her own paintings with them in 1877.

Like Degas, Mary favored painting in the theater. But she was less interested in the dancers than she was in the spectators. Cassatt also preferred images of children or mothers with their children – maybe because she missed

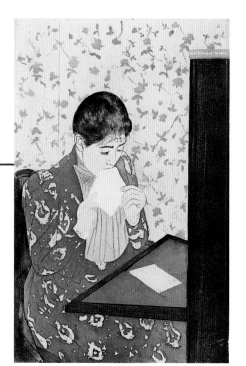

having any little ones of her own. Mary's paintings are mostly peaceful, full of warmth and affection.

Cassatt helped make the Impressionists well known in America. She frequently travelled back to her home country, and she advised her wealthy friends to buy paintings by Degas and Monet at that early point in time.

Worth Knowing
A film about Mary Cassatt's life was made in 1999: *Mary Cassatt: American Impressionist.*

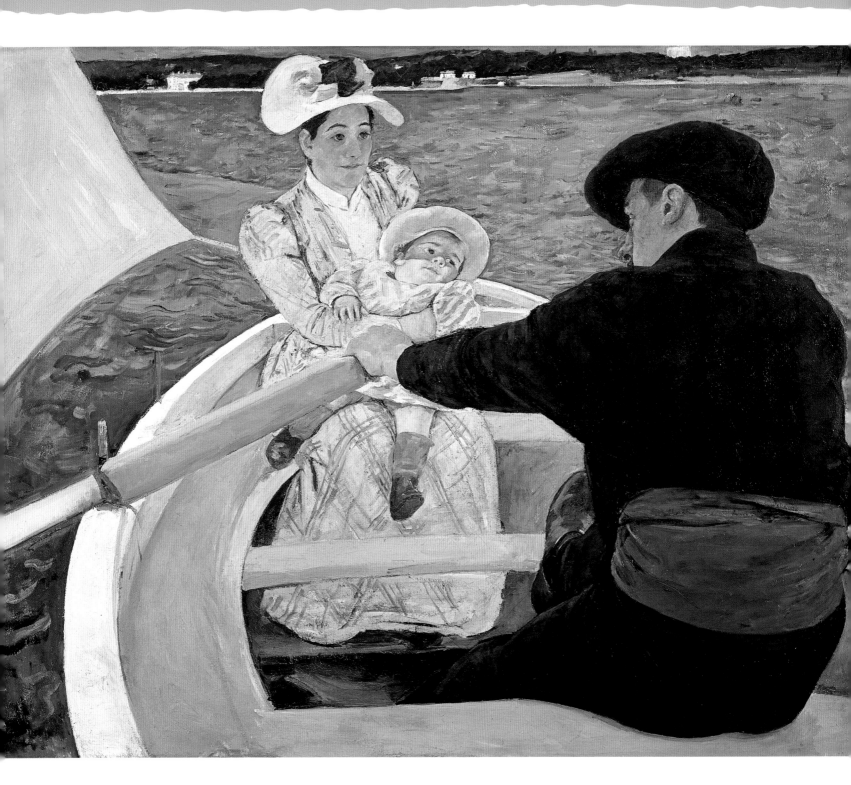

Mary Cassatt, *The Boating Party*, 1893/94, National Gallery, Washington

This picture looks like a snapshot. The rower needs a lot of strength.
He even has to press his foot down.

1810 German composer
Robert Schumann is born

1859 Charles Darwin
publishes *The Origin
of the Species*

1805 1810 1815 1820 1825 1830 1835 1840 1845 1850 1855 186(

Born
July 20, 1847
in Berlin
Died
February 8, 1935
in Berlin

Max was from a rich
family and had five
brothers and sis-
ters. His family lived
right in the center
of Berlin, near to the
Brandenburg Gate.

Max Liebermann

Max Liebermann did not like school one bit. He wanted
to draw and paint instead. So when Max was supposed to
be studying chemistry, he was off somewere making his art.
Max's parents soon realized that their son was destined to
become a painter.

Max therefore attended art school. And because travel is said to broaden
the mind, he toured Italy, France and Holland to study the paintings there. In
those days, the only way to see great art was by travelling to where the paint-
ings were displayed. Color photography did not yet exist.

The city that interested Max above all was Paris. This is why he hired a studio
there and started painting. Not surprisingly, he realized that the Impression-
ists were in the process of transforming art. Their work appealed to Max
Liebermann. The bright, cheerful paintings of
outdoor cafés were very different from Max's
dim and somber painting studio back in
Germany.

Liebermann increasingly adopted
the Impressionist painting style in
his own pictures. He always spent
summers by the sea in Holland,
where he could best try out his
new style.

28

Max Liebermann 1847–1935

1872 Berlin becomes the
capital city of Germany

1896 Mahatma
Gandhi is born

1914–1918 First World War

1865 1870 1875 1880 1885 1890 1895 1900 1905 1910 1915 1920

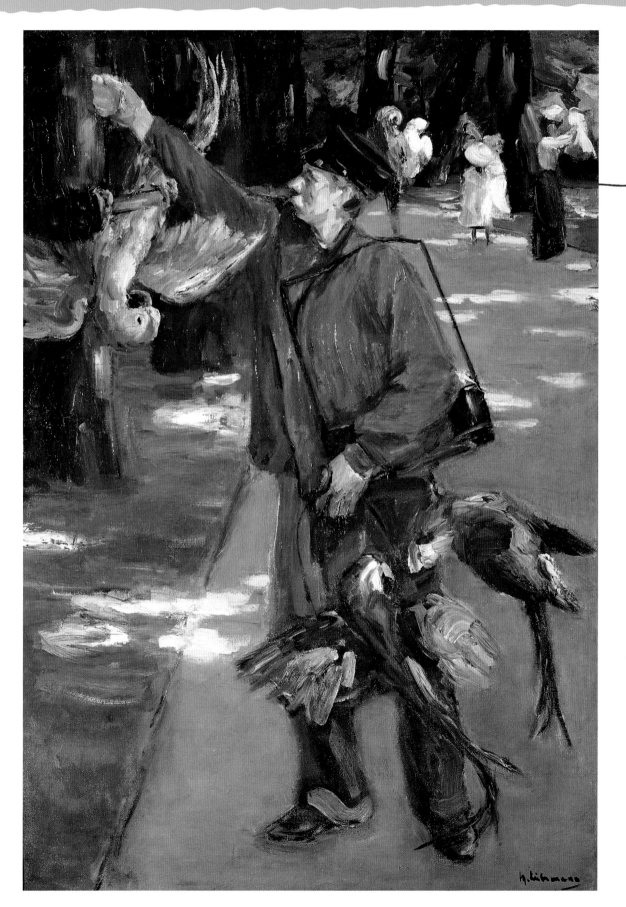

Max Liebermann,
The Parrot Man,
1902, Museum
Folkwang, Essen

This picture originated
from the zoo in
Amsterdam. At that time,
the zoo had a path where
visitors could see parrots
sitting in small swings
atop wooden poles.
This sight must have
been very colorful. Each
evening at the zoo, the
keepers would return
the parrots to their cages.

Max Liebermann,
Terrasse Restaurant Jacob in Nienstedten/ Elbe, 1902/03,
Kunsthalle Hamburg

Max Liebermann stayed at the Hotel Jacob for the whole summer and had plenty of time for this painting.

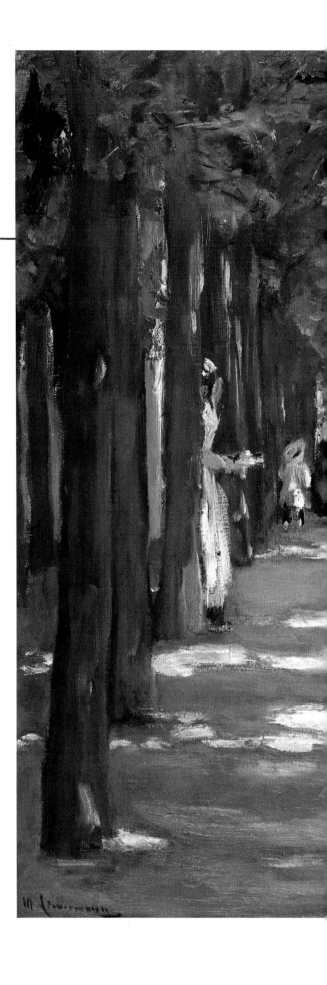

When he returned to Germany, Max was one of a mere handful there who knew Impressionist art really well. He specialized in painting beer gardens or parks where the light fell through the treetops and created little areas of shade on the ground … as you can see here at the *Restaurant Jacob*.

Max Liebermann became a successful and respected painter, and he helped make Impressionist ideas popular in Germany. Eventually, Liebermann became a professor at the Academy of Arts in Berlin. He even served as the Academy's president … quite an accomplishment for someone who once hated going to school!

Worth Knowing
Max Liebermann became one of the most significant painters of Germany. When the National Socialists (the Nazis) gained power in 1933, he was no longer allowed to work as a professor because he was Jewish.

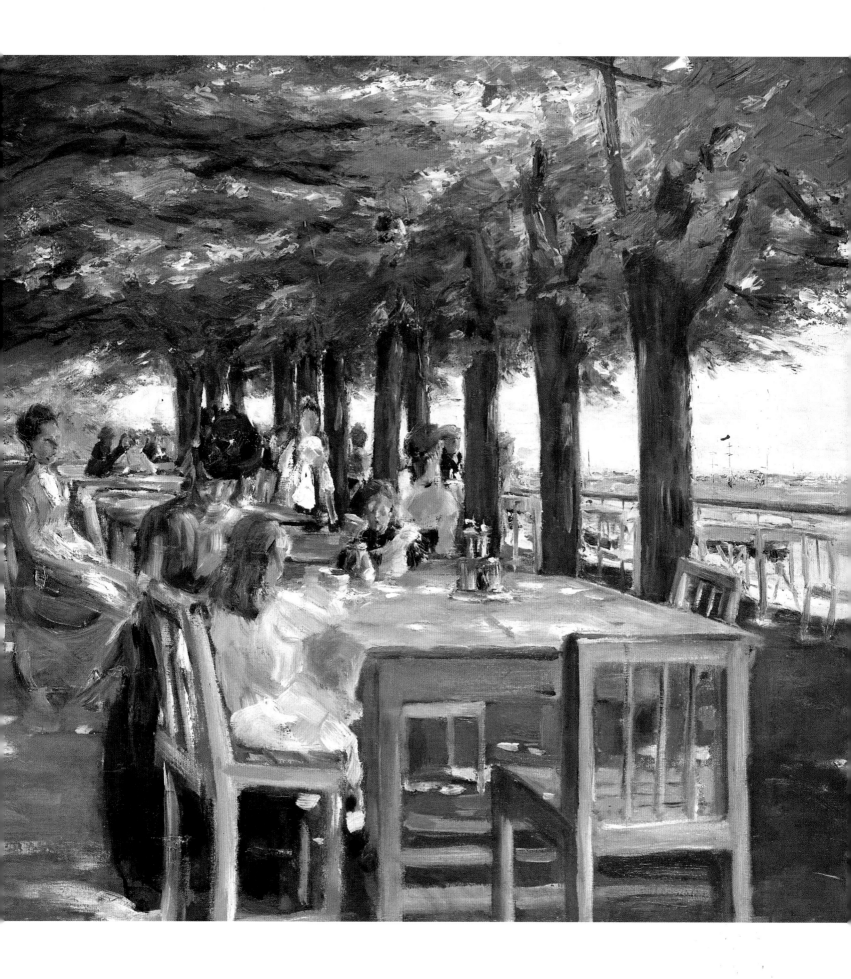

1806 End of the Holy
Roman Empire

1827 Ludwig van
Beethoven dies

1853 Elisha Graves Otis
invents the first modern
elevator

1805 1810 1815 1820 1825 1830 1835 1840 1845 1850 1855 1860

Born
December 2, 1859
in Paris
Died
March 29, 1891
in Paris

Seurat led a secretive
life. He lived with
a partner named
Madeleine, whom he
never married. The
couple had a son,
but Georges did not
tell his family about
Madeleine and the
child until shortly
before his death.

Georges Seurat

Seurat began to study painting at the Paris Academy in 1877,
only three years after the first exhibition of the Impressionists.
In 1879, after seeing the group's fourth exhibition, he was so
excited that he immediately ended his studies.

Seurat was totally fascinated by this new way of working with paint.
However, he wanted to make it brighter and more intense. He no longer
mixed his paints on a palette, but positioned them individually in small dots
onto the canvas – dot after dot after dot. These dots were arranged so that
the viewers' eyes would "mix" the paint as they gazed at the picture. When
you look at a Seurat painting from a distance, the dots seem to form rich
colors and interesting figures. His style was given the name "pointillism" –
namely, "painting dots."

Painting this way took a long time, and pointillism seemed to have little
in common with catching the so-called moment, or "impression." But in
Seurat's most famous piece, *A Sunday Afternoon on the Island of La Grande
Jatte*, we can see some features of Impressionist art. The picture shows the
same ordinary people that we see in work by Édouard Manet and Auguste
Renoir – ordinary people who are enjoying their leisure time outside. Yet
Seurat's method of painting makes them appear somewhat stiff and rigid.

Pissarro found Seurat's way of painting very interesting, and he invited him
to participate in the final Impressionist exhibition in 1886. However, Renoir
and Claude Monet believed that George's art was not truly Impressionist, so
they withdrew their own paintings from the exhibition. This was the reason
why Claude Monet – the very painter whose work had inspired their name –
was not at the last exhibition of the Impressionists.

1887 Arthur Conan Doyle publishes
the first Sherlock Holmes story

865 | 1870 | 1875 | 1880 | 1885 | 1890 | 1895 | 1900 | 1905 | 1910 | 1915 | 1920

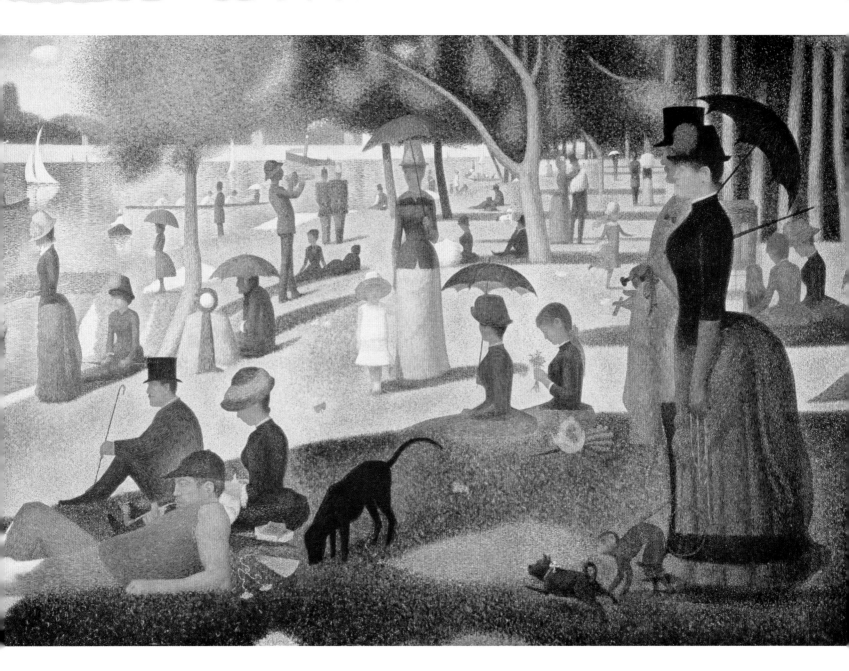

**Georges Seurat, *A Sunday Afternoon on the Island of
La Grande Jatte*, 1884–86, Art Institute, Chicago**

Nobody wanted to buy the *La Grand Jatte* until 1924, when an
American collector finally acquired it for $20,000 and donated it
to the Art Institute of Chicago. By 1930, the French realized how
important this painting was. A group of French businessmen
offered the museum $400,000, a huge sum at that time, so that
the painting could be returned to France. However, it remains in
Chicago today.

1821 Napoleon Bonaparte
dies on St. Helena

1840 Russian composer
Peter Ilyich Tchaikovski
is born

1860 The Pony Express goes into
service in the United States

1805 1810 1815 1820 1825 1830 1835 1840 1845 1850 1855 186

Childe Hassam, *Church at Old Lyme*, 1905, Albright-Knox Art Gallery, Buffalo, NY

The church was built in 1816 and burned to the ground two years after Hassam painted this picture. It was rebuilt in 1908.

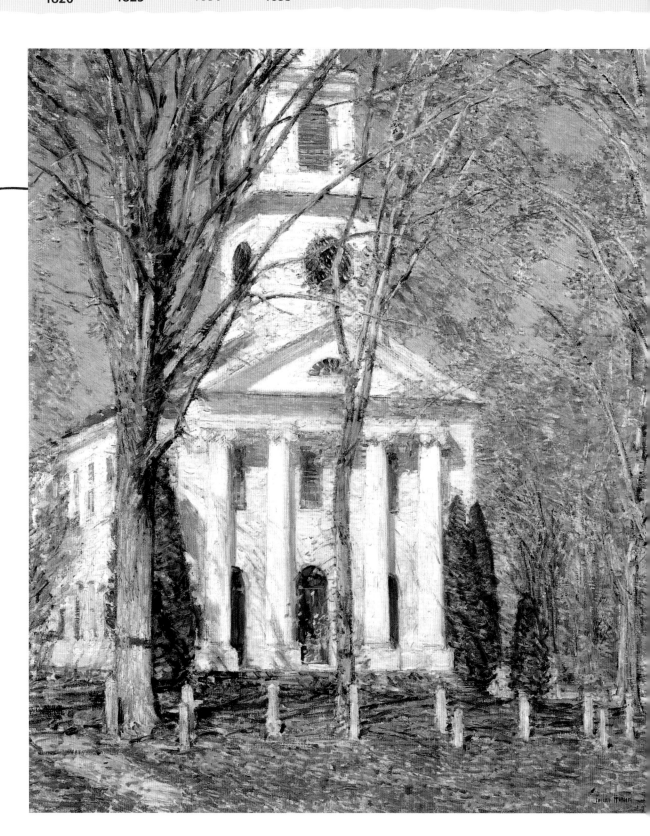

1870 Franco-Prussian War begins between Germany and France

1885 Carl Benz builds the first automobile

865 1870 1875 1880 1885 1890 1895 1900 1905 1910 1915 1920

Childe Hassam

Many artists like to travel because it allows them to find inspiration and encounter new art forms while on the road. The young Childe Hassam traveled from America to Europe in 1883 and painted in Great Britain, Holland, Spain and Italy.

On returning home, he had a good number of beautiful paintings in his baggage, which enabled him to set up a large exhibition. But at the end of the 19th century, if you really wanted to know what was going on in the world of modern art, you had to go to Paris. This is where the latest and most interesting art was to be found – the art of the Impressionists.

By the 1880s, Impressionism had become really famous. People were buying their works and artists were taking up their way of drawing and painting. Paris was the absolute center of the art world, even for artists from the United States. After seeing an exhibition in New York that included Impressionist pictures, Hassam thought to himself: That's how I want to paint, too.

As a result, he traveled to Paris with his wife in 1886 and stayed there for a full three years. This is where he really got to know the art of the Impressionists. Of course, he did not simply imitate them, but instead developed a style all his own.

In 1889, Childe returned to America. He had decided to paint everyday life in this own country, which was growing and changing quickly. During the summer, Hassam mostly painted scenes in the countryside; and in winter he focused on the streets of New York and Boston. His images were just like those of the French Impressionists, but they were made on the other side of the Atlantic.

Born
October 17, 1859 in Dorchester, Massachusetts

Died
August 27, 1935 in East Hampton, New York

Even at a young age, Childe was an enthusiastic illustrator and water colorist. He provided illustrations for magazines.

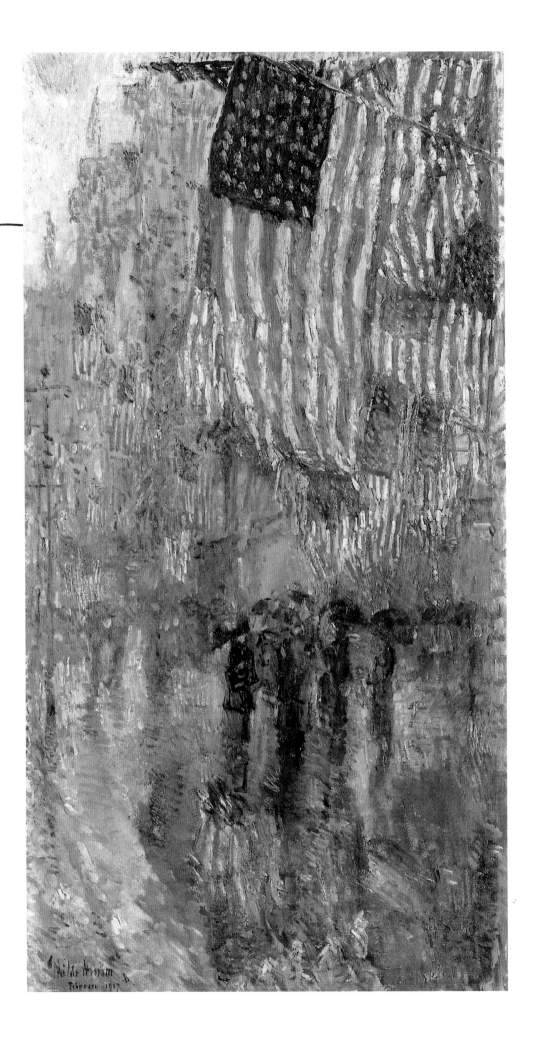

Childe Hassam, *The Avenue in the Rain*, 1917, White House Collection, Washington

The painting *Avenue in the Rain* belongs to a collection of the White House in Washington, D.C., and it actually hangs in the Oval Office.

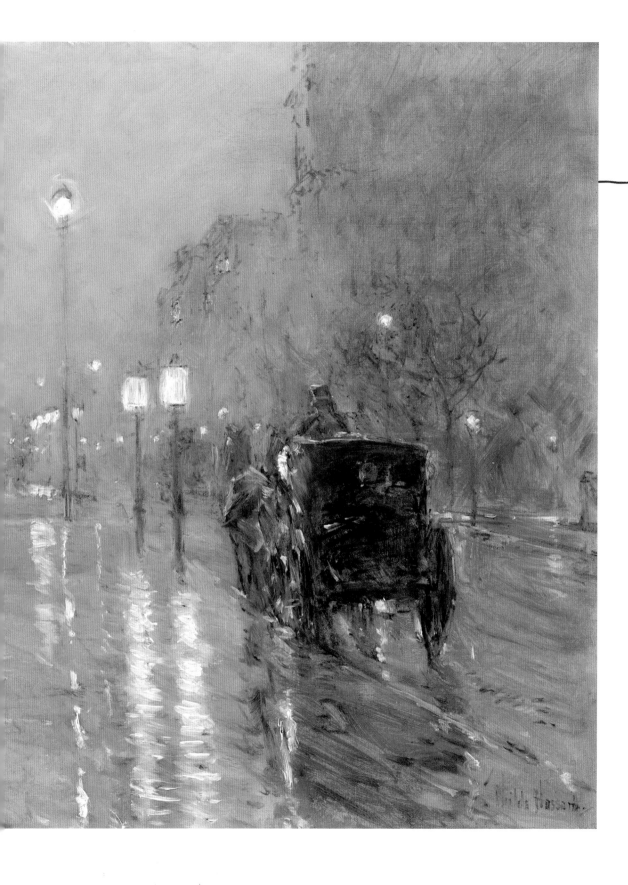

Childe Hassam,
Rainy Midnight,
1890, Museum of Fine
Arts, Houston, Texas

If you stand up close,
you can almost only see
blue and white strokes.
You can only recognize
the coach from a certain
distance.

Hassam often painted
pictures showing
bad weather. He was
attracted by the way
a rain-soaked street
could reflect the
objects around it, just
like a mirror. Why
don't you try to paint a
rain shower?

Childe Hassam once said: "The man who will go down to posterity is the
man who paints his own time and the scenes of everyday life around him."
Well, wouldn't you say that he succeeded perfectly?

Born
November 11, 1863
in Paris
Died
August 15, 1935
in Paris

Paul Signac was
married and had a
daughter. He lived in
the South of France
and in Paris.

Paul Signac

Paul first wanted to become an architect. But then he saw paintings by Claude Monet at a gallery and changed his mind altogether. That's when he decided to be a painter.

Signac learned to paint "auto didactically" – that is, he taught himself how to do it. At all times, Monet was his great inspiration. But there was a minor difference: Signac wanted his paintings to look more orderly than those of his role model. For Paul, Monet's pictures sometimes appeared too messy and unclear. He preferred to make paintings where all the elements – houses, people, objects, etc. – were more neatly arranged; just like painters had done in earlier times.

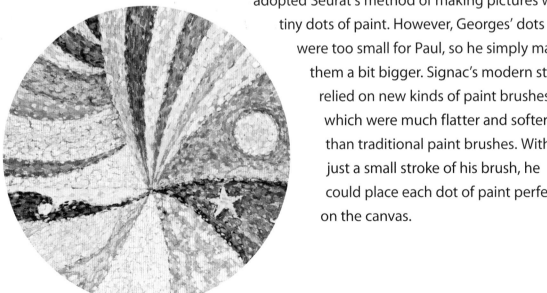

In 1884, Paul got to know Georges Seurat. He soon adopted Seurat's method of making pictures with tiny dots of paint. However, Georges' dots were too small for Paul, so he simply made them a bit bigger. Signac's modern style relied on new kinds of paint brushes, which were much flatter and softer than traditional paint brushes. With just a small stroke of his brush, he could place each dot of paint perfectly on the canvas.

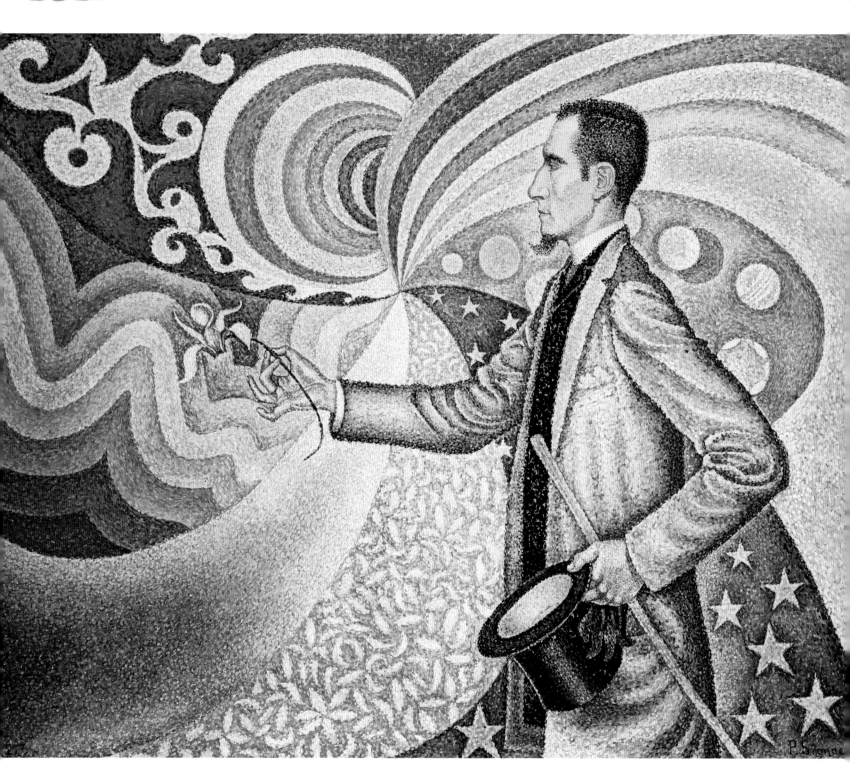

Paul Signac, *Portrait of M. Félix Fénéon*, 1890, Museum of Modern Art, New York

Félix Fénéon was a journalist, art dealer and critic. He coined the expression
'neo-Impressionism' for the painting style of Signac and Seurat.

Paul Signac, *Grand Canal, (Venice)*, 1905, Toledo Museum of Art, Toledo, Ohio

This picture looks like a painted mosaic. Although each daub of paint is separate and bright, it looks very uniform.

When making his pointillist art, Signac would often begin by drawing images quickly in watercolor. He would then use the best of these watercolors as the basis for larger paintings, which he would create later in his studio. With this approach, Paul drew over 200 watercolors on a trip to Venice. Only two of these pictures were used to make finished paintings.

Worth Knowing
One day, Paul got to know a young Dutch artist in Paris, who found his method of painting very exciting and adopted the style in his own way. At the time, this young artist was almost completely unknown. Only colleagues and friends were familiar with his work. Nowadays, everyone knows his pictures, even children … for he was Vincent van Gogh.

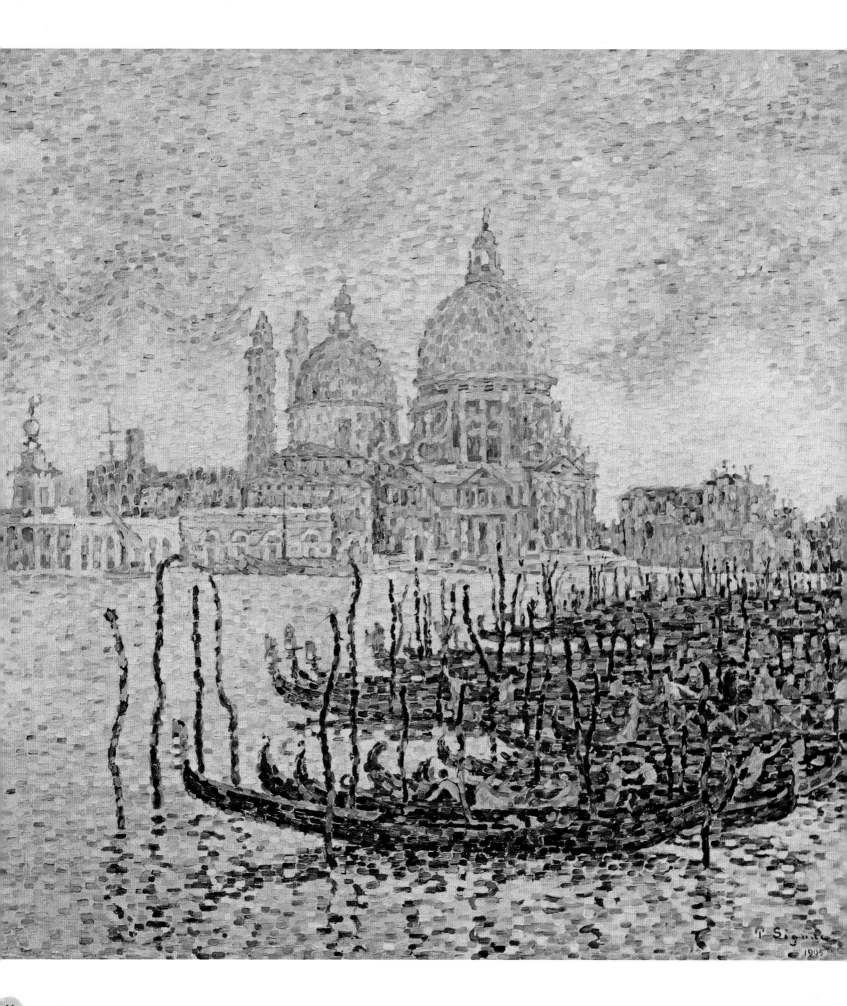

✸ 1805 Birth of Danish storyteller
Hans Christian Andersen

1843 Charles Dickens ✸
publishes *A Christmas Carol*

✸ 1851 The first World's
Fair is held in London

| 1805 | 1810 | 1815 | 1820 | 1825 | 1830 | 1835 | 1840 | 1845 | 1850 | 1855 | 1860 |

Born
January 12, 1856
in Florence
Died
April 15, 1925
in London

John had four siblings. He travelled throughout his whole life, visiting many parts of Europe and America. However, it was only in Paris and London that he lived for a longer period of time.

John Singer Sargent

John Singer Sargent grew up quite differently from most of us. He was an American, but for health reasons his parents lived in Europe, where they would move from one place to another every couple of months.

John was born in Florence, Italy, and he hardly ever went to a proper school. Sargent was actually taught by his father, FitzWilliam Sargent, who was an eye doctor. With his father's help, John learned to speak German, Italian and French. But the young student often disliked his studies. FitzWilliam once commented about his son: "Johnny, particularly, is much more fond of climbing and kite-flying than he is of spelling – and, in truth, I like him all the better for it."

Sargent loved to paint more than anything else. And because of the constant travelling here and there, he had very few friends and spent a lot of time drawing. Through his family, John also got to know many different painters.

John's parents detected his special talent and moved to Paris in 1874, with a view to providing him with a sound training. His most important teacher was Carolus-Duran, one of the most successful portrait painters of his time. John himself went on to become an even more successful portrait artists – the most popular in all of Europe.

Actually, John Singer Sargent was not really a proper Impressionist. He never even exhibited his work with other Impressionist artists. Sargent was one of many painters who used Impressionism's freer, more informal painting style; but who did not become part of the movement. In truth, this style was no longer considered radical and new … it was now accepted as normal by artists around the world.

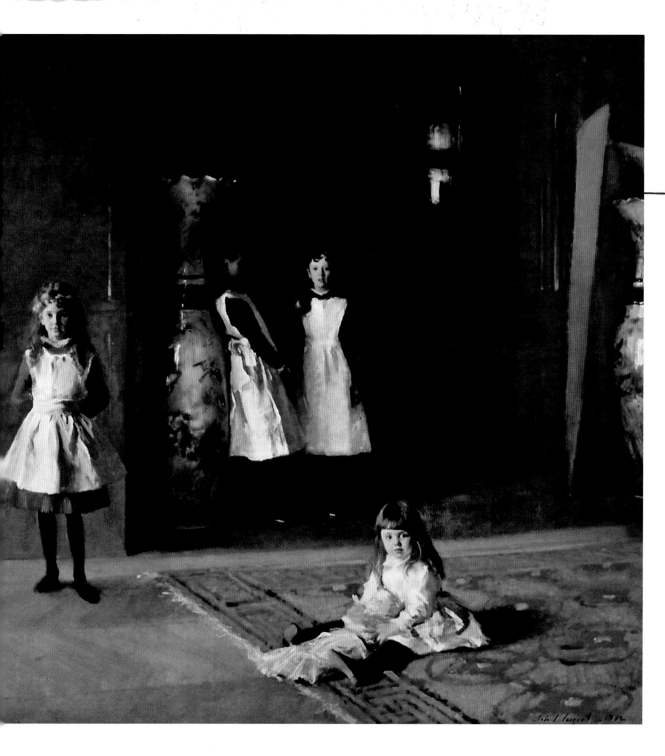

John Singer Sargent,
***The Daughters of Edward
Darley Boit,*** 1882,
Museum of Fine Arts,
Boston

John Singer Sargent
was inspired by the
famous painting *Las
Meninas*, which was
made by Spanish
artist Diego Velázquez
(1599–1660). Velázquez
was also a role model for
the Impressionists, who
admired the older artist's
rough but beautiful
brushwork.

Where Impressionism Made its Mark!

FRANCE

The Impressionists painted anywhere they fancied and where light shone beautifully. With the new paint tubes then available, they were better placed to paint outdoors and no longer need to go back to their studios to make pictures from their sketches as they used to do.

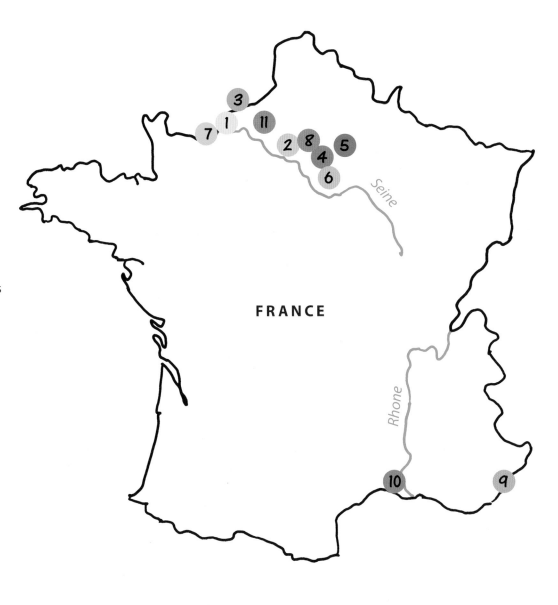

FRANCE

Seine

Rhone

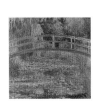

1 Le Havre

Claude Monet,
Impression Sunrise

2 Giverny

Claude Monet,
Water Lilies and Japanese Bridge

3 Etretat

Claude Monet,
The Cliffs near Dieppe

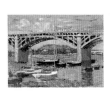

4 Argenteuil

Claude Monet,
The Bridge over the Seine

5 Argenteuil

Pierre-Auguste Renoir, *Monet Painting in his Garden*

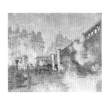

6 Paris

Claude Monet,
The Europe Bridge, Saint-Lazare Station

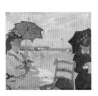

7 Trouville

Claude Monet,
The Beach at Trouville

8 Pontoise

Camille Pissarro,
The Hermitage

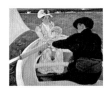

9 Antibes

Mary Cassatt,
The Boating Party

10 Arles

Vincent van Gogh,
The Café Terrace on the Place du Forum

11 Rouen

Claude Monet,
Rouen Cathedral

PARIS

The Impressionists painted modern city life: people in cafés and swimming, the hustle and bustle of the streets, horse racecourses and the new grand boulevards. You can still find this going on in the Paris of today.

If you would like to actually see the artworks of the Impressionists, the best places to go are the following museums: Musée d´Orsay **A**, Musée Marmottan **B** or Musée de l´Orangerie **C**.

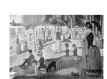

2 La Galette Windmill, 83, Rue Lepic

Pierre-Auguste Renoir, *Dance at the Moulin de la Galette*

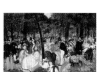

3 The Tuileries Gardens

Edouard Manet, *Music in the Tuileries*

4 The Island of La Grande Jatte

Georges Seurat, *A Sunday Afternoon on the Island of La Grande Jatte*

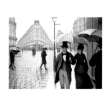

1 Place de Dublin

Gustave Caillebotte, *Paris Street, Rainy Day*

5 Saint-Lazare Station

Claude Monet, *Saint-Lazare Station: Arrival of a Train*

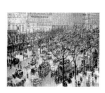

6 Boulevard des Italiens

Camille Pissarro, *Boulevard des Italiens*

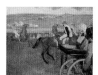

7 Paris Opera (The Palais Garnier)

Edgar Degas, *Ballet Dancers / The Star (L'étoile)*

8 Longchamp Racecourse the Bois de Bologne

Edgar Degas, *At the Races*

9 Les Folies Bergère, 32, Rue Riche

Edouard Manet, *Bar in den Folies Bergère*

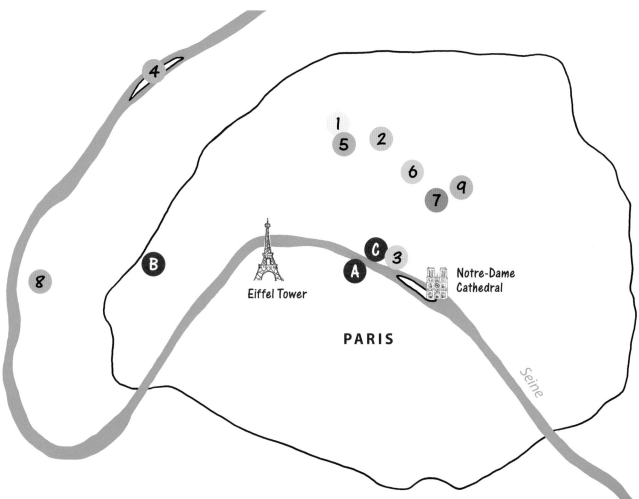

Answers to the Quiz Questions

Page 6: A client was so pleased by the *"Bunch of Asparagus"* that he gave Manet 1,000 francs for it – much more than was wanted. As a result, Manet painted him an extra asparagus stalk.

Page 9: It's estimated that Monet painted the picture in less than an hour.

Page 17: Mrs. Havemeyer, a friend of Mary Cassatt, bought the painting in 1912. She paid more money for it than a house in Paris would have cost. It was the most expensive painting by a living artist at that time.

Page 24: More than a million people lived in Paris in 1850. By 1880, the city's population was double that number!

© Prestel Verlag, Munich · London · New York, 2015

Front cover: Details taken from: Georges Seurat, *A Sunday Afternoon on the Island of La Grande Jatte* (p. 33); Claude Monet, *Poppy Field Near Argenteuil*, 1873, Paris, Musée d´Orsay; Mary Cassatt, *The Boating Party* (p. 27).

Frontispiece: Édouard Manet, *The Balcony*, 1868/69, Musée d´Orsay, Paris

Picture credits: The illustrations in this publication have been taken from the Publisher's archives, with the exception of the following: akg-images, p. 6, 39, 40-41, Bridgeman Images: p. 37, Christie´s Images Ltd – Artothek: p. 13, Joseph S. Martin – Artothek: S. 25, 33, Peter Willi - Artothek: Cover (middle), p. 18-19.

Portaits: Édouard Manet, approx. 1867–1870, photography by Félix Nadar; Claude Monet, 1899, photography by Félix Nadar; Auguste Renoir, approx. 1900, photograph; Gustave Caillebotte, *Self-portrait*, approx. 1892, oil on canvas, Musée d´Orsay, Paris; Edgar Degas, 1860, photography by Étienne Carjat; Berthe Morisot: Édouard Manet, *Berthe Morisot*, 1872, oil on canvas, Musée d´Orsay, Paris; Camille Pissarro, approx. 1900, photograph; Mary Cassatt, *Self-portrait*, 1878, gouache on paper, Metropolitan Museum of Art, New York; Max Liebermann: Nathaniel Sichel, *Max Liebermann at Age 16*, 1863, drawing; Georges Seurat: Maximilien Luce, *Georges Seurat*, 1889, drawing; Childe Hassam, approx. 1903, photograph; Paul Signac: Georges Seurat, *Portrait of Paul Signac*, 1890, conté-chalk on paper, private collection; John Singer Sargent, approx. 1880, photography by Paul Berthier

Prestel, Munich
A member of Verlagsgruppe Random House GmbH

Prestel Verlag
Neumarkter Strasse 28
81673 Munich
www.prestel.de

Prestel Publishing Ltd. Prestel Publishing
14-17 Wells Street 900 Broadway, Suite 603
London W1T 3PD New York, NY 10003
www.prestel.com

Library of Congress Control Number is available; British Library Cataloguing-in-Publication Data: a catalogue record for this book is available from the British Library; Deutsche Nationalbibliothek holds a record of this publication in the Deutsche Nationalbibliografie; detailed bibliographical data can be found under: http://dnb.ddb.de

Prestel books are available worldwide. Please contact your nearest bookseller or one of the above addresses for information concerning your local distributor.

Project Management / Photo Editor: Katharina Knüppel
Translation: Paul Kelly
Copy Editor: Brad Finger
Design: Michael Schmölzl, Munich
Layout: Meike Sellier, Eching
Production: Astrid Wedemeyer
Lithography: ReproLine Mediateam, Munich
Printing and Binding: Printer Trento, Trento

MIX
Paper from responsible sources
FSC® C015829

Verlagsgruppe Random House FSC® N001967
The FSC®-certified paper *Hello Fat Matt* has been produced by mill Condat, Le Lardin Saint-Lazare, France.

ISBN 978-3-7913-7205-1